T0199182

Capital Sketching

LORI VAN KIRK SCHUE

To order additional copies of this book, contact:
Xlibris
1-888-795-4274
www.Xlibris.com
Orders@Xlibris.com

ISBN: Softcover 978-1-7960-8421-4
 Hardcover 978-1-7960-8422-1
 EBook 978-1-7960-8420-7

Print information available on the last page

Rev. date: 01/25/2020

Contents

What is the Art of Sketchbooking?

Sketch: *an undetailed drawing sometimes made as a preliminary for a painting or other more finished piece of art such as sculpture.*

Sketchbooking: To record visually.

There's the bugaboo! A less detailed, quick drawing is sometimes harder to achieve than a full-blown detailed masterwork. Because, in that simple little sketch goes a lot of observation and planning, listening and seeing, feeling and experiencing. Especially when setting out to create a visual journal of our adventures. My students often enter class with a notion of sketch booking as a mission to fill their paper pad of choice with beautiful works of art and, are sometimes annoyed when I tell them "this is not a drawing class." In a sense, it is a drawing class, but it is distinctly not a drawing class in the *classical* sense. No formal training for capturing realistic detail and likeness will occur. Instead, an approach to connecting with your world on a more sensory level will reign paramount so that you can visually document the world of which you, on some level, participate. Sketch. Grab the essence quickly because the bus is moving or more slowly to let the experience soak in, but, sketch. Record and tell the story of your adventure, your life, your moment.

In this book you will follow me as I trek our nation's capital, sketching as I go. Why Washington, DC? Why not? It is a city of diversity and beauty as are most capital cities. Thus, you can take these tips with you when visiting any capital city on our globe and enrich your travels by sketching your memories and adventures to share or not. The act of sketching alone will cement whatever you choose to include in your sketch book for eternity.

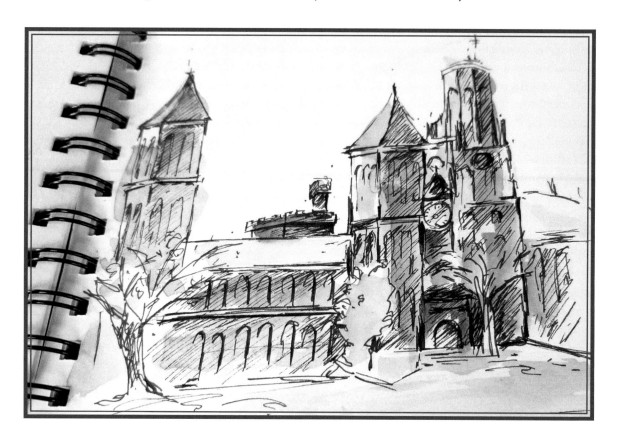

Why is Keeping a Sketchbook Important?

In our busy, fast paced, technology driven world it is simply refreshing to slow things down a bit with sketch booking. To me, drawing and recording in my sketch book is something I so look forward to every day. A good habit that restores me. It is important for me to do this activity. To clear and clean my thoughts by allowing others to influence, at least in some small way, my universe. Why it is important for you might differ. But I think overall, people who learn to use a sketch book to make a record of their thoughts, experiences, and adventures, both visually and literally, have found a way to engage invisibly. By that I mean they can become very engaged in what is happening without and within and no-one may see what they see or even that they are seeing. Once you learn to use a sketch book you will look upon it as a friend you meet daily, take on trips, share thoughts with and reminisce with.

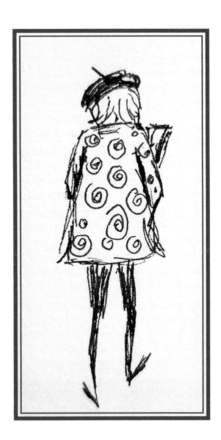

Learning to See by Mastering Stillness

Expand your vision by simply being still.

To allow your brain to make the most of your world, at any given moment, may require you to simply stop and quietly observe. For some, this can be grasped instantly; slowing down and tuning in. For others, meditative techniques may need to be employed. Finding a place to sit down, close your eyes and inhale and exhale can help to "let the world in" in a useful way. Once you can be still, you suddenly allow your senses to escort you into a world where seeing more completely becomes easier.

Achieving this stillness may take some time but once you can master your stillness you are on your way to a world perhaps you may have never known before.

Recognizing the difference between simply being quiet and stillness, will allow your other senses to take part in the experience. Suddenly you may hear more, smell more and yes, see more. Natural sounds and scents join the cacophony of voices and odors. All of these nuances enlighten you to your actual surroundings and in essence help you "see" better.

How you react, absorb and include this new information in your sketching is personal. However, you must admit you actually have more information than before and are freely seeing the world to interpret.

A sketch of a building may have beautiful line quality and color. But, ask yourself, why am I choosing that building to sketch? What role is that particular building playing in my world at this moment? Where is the life, color, action and placement? Do you simply sketch the building maybe throwing in some color? Or do you include the placement on the avenue, the wind-blown trees or people scurrying to get inside? Tell the story. The whole story. As you "see and sense" it.

Including information reminds you of the day, the experience you had on a windy afternoon with a storm fast approaching. Instead of a random building sketch with nothing to convey except the fact that you saw a building. Your sketchbook, your visual journal deserves more.

Communicating

So, now you have mastered stillness. You can glean information to include into your sketch book by defining simplistic complexity. That is wonderful, bravo! But how are you really communicating? Assess what you have done so far. Be honest. Are your sketches truly communicating what you are seeing, hearing, feeling? Here are some tips to help impart information through sketches.

- Pay attention to <u>light</u>. What time of day is it? Where is the light source? How is the light affecting mood? Is the light revealing information that was once hidden in shadow? How are you depicting all or any of the above?

- <u>Sounds</u> play a definitive role in sketching by drawing your attention. Sound alone can make the decision to include this sketch or not in your sketch book. The child crying, the crash of metal, the beep, beep, beep of a construction truck backing up, the music from a carousel all command attention and therefore draw your focus to what is happening. Perfect opportunities to put pencil to paper.

- <u>Pictures with sub-pictures</u> clarify what you see. A beautiful Navajo necklace can be communicated by quick sketching the general shape, color and texture. But, a sub-sketch or smaller detailed sketch of a portion of the exquisite craftmanship communicates the awesomeness of this work of art.

- Employing the <u>*Rule of Thirds*</u> helps communicate location, scale, and interest in the composition of objects in your sketch. This easy technique helps add excitement to your sketches by simply separating your page into thirds by drawing two vertical lines crossing two horizontal lines and placing points of interest on those lines and intersections.

- <u>Atmosphere</u> dictates mood and feelings. Were all of your sketches created on sunny days? Try doing some sketching on rainy or snowy days both outdoors and in. Sitting by a window observing how the snow accumulates on a parked car or birdfeeder makes for a special and unusual series of sketches. Don't forget, atmosphere can also describe the feeling surrounding you. Think of the heady excited atmosphere when waiting for a rock concert to begin. Capture fellow concert goers in a quick sketch complete with heads thrown back in laughter and anticipation.

- <u>Movement</u> is the last tip I will mention here as it can be rather difficult to convey via sketch. Again, concentrate on seeing by watching trees or paper blowing in the wind, children running or buses moving along city streets or even waves crashing on the beach. Avoid drawing lines to show movement but rather organic morphing of shapes.

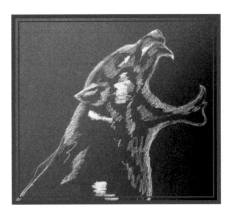

What Makes a Worthy Image?

Now that you have mastered your ability to be still and sponge up all of the information that is integral to telling the story, what makes a worthy image for inclusion in your sketchbook?

Sometimes, everything is up for grabs. Going at it with complete abandon, sketching wildly to grasp every little happening, can make for a fun filled sketching flurry. I highly recommend doing this every now and then to run amok in creativity. It is a freeing and serendipitous way to spend some time sketching.

Yet, there is the need of sketching mindfully that sometimes can be very weighty. I must present a thoughtful sketch, a complete sketch, a communicative sketch. Please! By the sheer definition of sketching keep things simple. That's not to say you shouldn't sketch details that are important to the story, just don't allow yourself to get burdened with too much information. Less can be more as you know.

Simplistic complexity is the answer. How much is too much? Did I not include enough? Attack these issues with a laze-faire attitude. After all, this is your story, your sketch book, your experience. However, when the desire is to capture an image and a serious sketching attitude is needed, think of the following: line and placement, textures, colors, and contrasts.

Ask yourself, in your stillness, what is amazing about this place, object, person? Convey that through your simplistic sketch by including complex characteristics. By doing so, you communicate its awesomeness, its worthiness.

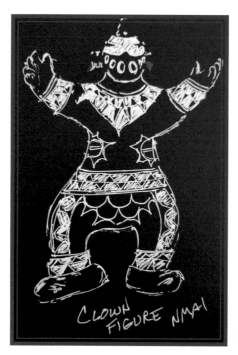
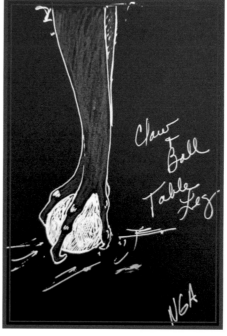

Quick Sketch vs Detailed Drawing

I often remind my students that learning to sketch is not a Drawing 101 class. In other words, we are not learning to create replicas of what we see but impressions of what we see. Of course, there is value in having drawing skill and knowing all the classical rules. Yet, in sketching we are not as concerned with those ideas. Sketching for record and communication sake is better accepted not by unrecognizable marks on paper or exquisite Da Vinciesque drawings but somewhere in between. This is where doing some research may help you. Look at another sketchers work. See how they handle line, form, etc. in a quick drawing. Sketches are drawings that communicate, and record, unburdened with perfectionism. Do you ban all forms of classical drawing in your sketchbook? Of course not. Sometimes you simply want to go whole hog into every detail of what you are seeing and record it all. That too is a part of your visual journal. However, not everything has to carry that weight of perfection or you will become paralyzed with expectation. Unable to perform at a moment's notice to that high expectation will kill your creative, spontaneous goal of sketching.

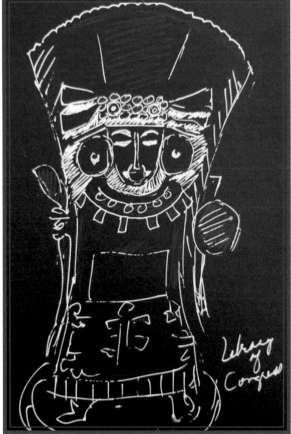

Realism vs Emotive

One very important skill in sketching is the ability to create convincingly without having to provide every aspect of information. In other words, what makes the apple an apple? Is it the fact that it has a certain shape, leaf, color? Or can a circular shape with a stem convince people it is an apple? In sketch, simplicity is key so that you can get on with telling the story.

You must practice identifying emotion, as well, in your sketchbook story telling. Must you draw every detail of the crying baby's face or can you get across the emotion, the feeling of the situation by including other information in the sketch? In this case, perhaps the fact the baby has fallen down and skinned his knee. The frown may be all you need to have an emotive sketch.

Style Discovery

How you handle your sketching will determine your style. If you are a very precise, detailed, super organized individual you most likely will approach sketching with a clean line style. No fluffy extra bits of line in your sketches. You have a style all your own that closely resembles what you are sketching from the start. Your method dictates this.

If you are one who approaches your subject with an energetic line making many swipes on the paper before settling into the bits that convey to us what you are seeing, then your style has shown itself. A light vibrating sketch whisking you away on the adventure.

Neither is right or wrong. Both are correct. You, simply being you, show us your style. Rare is the artist who readily switches their approach from one to the other. Your style lives in your soul and reveals itself through your art. If you don't believe me, look through your sketches and pick out those that you feel are most successful. One reason is because of your "style" showing up.

Discovering your style may feel like a good friend, a comfort and joy that is dependable. Or, your style may show up one day and be somewhat of a surprise that you can live with. Either way, you will accept your style when you realize it is the way in which you feel good about what you have done. Don't try to copy someone else's style. Be you.

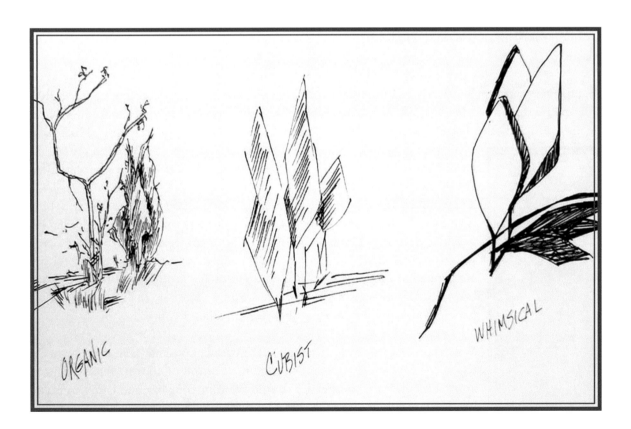

Mobility

Most of the time when sketch booking you are out and about and usually standing. It is extremely important to set yourself up to be mobile if you are going to be successful at sketch booking. Too many times I see budding sketchers loaded down with unnecessary art materials for a day out. Paring your supplies down to a basic few and adding on once you get more comfortable is key. Here are some valuable tips to simplify your sketching life and not annoy the world around you.

Choose a sketchbook that you are able to hold in one hand while sketching with the other in a crowded museum. In other words, do not bring the giant sketchbook that wipes out everyone around you and blocks the view. Your arm will get tired and your sketching adventure will end early. I like to choose a sketchbook with the following qualities:

- No larger than 9x12 and no smaller than 5x7

- Spiral bound allows you to turn the cover and pages back on itself, so you are not trying to hold an open book.

- Choose a sketchbook with multimedia paper so you can use pencils, markers or watercolors.

Choose one or two drawing pencils at the most. An HB or B is fine. Bring an eraser too and a closed pencil sharpener. DO NOT bring a pencil sharpener that allows the filings to drop all over the floor. Often, I grab a yellow No. 2 pencil and pop an eraser on top of it. I'm sketching, after all, and it does the job. Mechanical pencils are also an option. Not the ones used for writing but an artist's mechanical pencil which has a thicker, more sturdy lead.

Choose a bag for your supplies. Keep it in proportion for what you are bringing. You don't necessarily need a giant tote when a small satchel will do. Be aware that backpacks, while great for carrying things can be a problem in some museums and other bag checked areas. You may be asked to hold it by one strap only. I like something

I can wear across my body, so I don't have to sit it on the floor to cause a tripping hazard. Also, it is not causing fatigue by weighing down my arm or shoulder.

These three items can set you on your way for a successful sketching trip. However, if you would like to bring a pen, I recommend a permanent ink pen, then it is easy to add to your bag. If you want to use color in your sketches, try colored pencils or watercolors. PLEASE do not try to use open water containers as they tip over and are banned in a lot of places such as museums and art galleries. Instead, use a water brush made with a tube for the handle. Simply unscrew the brush tip, fill the tube handle with tap water, replace the brush tip and off you go.

When taking a group of pens or pencils, instead of placing them in a zippered pocket to keep them from swimming around the bottom of your bag, put a rubber band around them. It makes it easier to find them in your bag and easier to hold in the hand that is also holding the sketchbook. Sliding pens or pencils in and out of the bundle is easier too.

Of course, digital sketching is also now an option to explore on phones or tablets.

Being Brave

One issue a lot of my students have, no matter what their confidence and skill level, is the issue of sketching in public. Often, I have a student that shies away from sketching in places where other people might see them and view their artwork. Sometimes, when taking a group of sketchers into a museum, I will notice that I haven't seen one of them in a while. I then go to a room in the museum off the beaten path and there they are. Away from prying and judging eyes.

Yes, people seem to get excited when they see an artist drawing or painting in public. Why this is I am not sure. Yet it is part of being out there doing what you love so you might as well get used to it.

Don't be shy about grabbing your sketchbook and getting down what you are seeing. Remember, that is one part of what makes sketching so wonderful, the spontaneity of it all.

Yes, people will notice you. Yes, they may stare and look over your shoulder. Yes, they may criticize your work. And yes, they inevitably ask, "Are you drawing?" To which you will reply, "Why yes I am. Would you like to see?" They are harmless, and I guarantee, <u>you</u> will be the thing they remember about their trip. So, just go for it for the sake of your art.

Be brave!

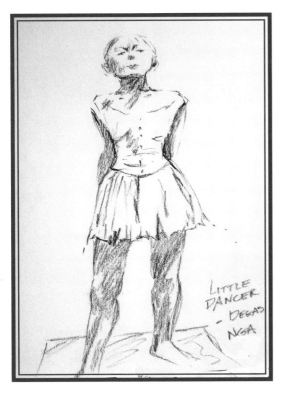

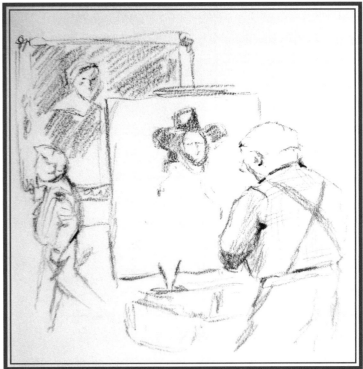

Simplifying Your World

To be successful at sketching you must learn to simplify your world. By this I do not mean to negate everything that was said about telling the whole story when learning to see. Here I mean to help you simplify by capturing the essence and moving on with the story.

One way to do this is to start studying and recognizing what detail to keep and what to omit. Easier said than done. Keep the French flag to help identify the French embassy, omit a precise count of windows. Keep the dog sitting on the couch, omit the magazines on the coffee table. Keep the girl at the café, omit the trees on the street.

It takes practice to identify what is crucial to telling the story, even if it is just to yourself, and what people will never miss. What is crucial to the plot and what is backstage noise?

We know dogs have fur. No need to sketch every bit of fur. We know trees have leaves. An organic shape to represent the leafy foliage is all that is needed. Simplify but capture the essence. Instead of a Dickensian novel, a haiku will do.

Telling the Story

A sketchbook is a visual journal. Instead of writing about your life, you are telling it in pictures. That can be a daunting task. Sometimes you need to add information to your sketch that just isn't possible when keeping up the spontaneous nature of your art.

One way to capture and add more information to your sketch story is to quickly add color so you may be reminded later of the amazing blue sky that day or unusual color of green shirt your friend was wearing.

Using colored pencils or watercolors are two appropriate methods for sketching. Colored pencils are easy enough to tote around. Choose only a handful as you won't need a set of 130 colors. I choose the primary and secondary colors, red, blue, yellow, green, purple, orange. That seems to cover about every scenario. Sometimes I will bring a travel watercolor set along. A travel set is made to be mobile. It is a small hinged box with a variety of colors that adds a nice touch to my sketches. I always carry a water brush with my set and never burden myself with a water container, bottle of water and brushes. You may want to try some water-soluble colored pencils. These unique pencils are made with a water-soluble pigment. You add color as with regular colored pencils and then apply water to turn it into the look of watercolor paint.

Getting back to telling the story, you should always create an *aide-memoire* with your sketches. This is simply another word for writing notes to aid your memory. In a few words, write a note near your sketch that explains it more fully. An aide-memoire, for instance might be, "the blue was like a robin's egg." Or, you may simply note the date and time and where you did the sketch. Don't rely on your memory.

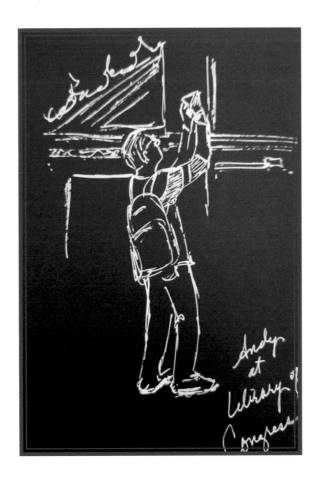

Helpful Drawing Rules (in a nutshell)

Here are some drawing rules that are good to know and can help you with your sketching.

Use contour line to establish the subject quickly. Contour line is simply the outer line of a shape or subject. It is the edge that defines the object from the space around it. This is important to establish the subject quickly on the page.

Negative and positive space can help you identify dimension in space. Positive space is the object. Negative space is the area not occupied by the object.

Sight sizing is a technique used to help with scale, placement and relationships of objects. Using a pencil is one way to do this. Close one eye, hold the pencil in front of you and use your thumb to measure down the pencil to accurately determine the size of the object to be related in your sketch.

Framing can also be used to determine size and composition. Cut a rectangle out of a piece of card. Hold this up to find the best composition of objects for your sketch.

Determining scale is important to convey how small or large things are. Placing a person next to the Lincoln Memorial can show the scale of the monument.

Shadow rules are somewhat intuitive. First establish the light source. Light on the right means shadow on the left and visa versa. High noon means shadows are short compared to evening when shadows appear long. Shadows also follow the general shape of the object or combinations of objects. Shadows are never black. They are combinations of present colors.

Reflections on water can cause issues unless you know the rules. Still water gives a mirror image reflection. Moving water gives a rippled image. Deep water gives clear, deep reflections. Shallow shows reflected and refracted shapes from the bottom. Sky reflects on water. A reflection is always below the thing being reflected and rarely the same as the reflected object. In general, the further back something is in a group the less you may see its reflection.

In sketching, gestural drawing or a quick grasp of movement can be accomplished with simple lines and no detail.

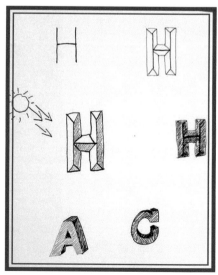

Collage (When sketching won't do.)

Embark on your sketching journey knowing you will have days when your pencil feels alien to you. It happens. On those days, don't give up. Now is the perfect opportunity to try something new. Many sketchbookers use collage to create their images. Collaging is simply choosing bits of papers, string, photos, etc. to make a pleasing image representative of what you feel or see.

I often collage animal images choosing just the right materials to convey the personality of that dog or cat. Sometimes a song sends me searching for printed music or lyrics and I sketch around them showing what it means to me.

Try it. One thing for sure is it will help your sketchbook have new life.

Developing Your Sketch Book
While Soul-Searching

I started writing this segment of the book several times. Many times, I deleted what I wrote because I was afraid of being heard as too heavy for a topic as light as sketching. But then I remembered a student in one of my classes who was just like any other student. Apprehensive at first, eager to learn and improve, I found her pleasant and dedicated to the tasks at hand, getting her life in sketches into a book.

She was somewhat quiet but joined in sharing her sketches with other classmates. After weeks of visiting museums, government buildings and a variety of interesting places Washington, DC has to offer, we all had become friends looking forward to sharing this adventure together.

By the time our series of classes came to an end, I, as always, was sad to let go. Had I taught them well, answering all their questions and urging them to be brave? Time would tell.

On the last day of class this student came up to me and told me a story about how much she really enjoyed the class and how coming each week for dedicated sketching time had healed her. Apparently, all this time she had been struggling with determining her next steps in life after the loss of a loved one. She had gotten over the pain as much as anyone could but seemed to be adrift. One day she received a catalog of art classes. Having worked in a government job for years she suddenly remembered how much she loved her college art classes. Not knowing what to do next or how to express her feelings she decided to take this sketching class. Through sketching each week and in fact every day she found a path to put one foot in front of the other and carry on. I asked to see her sketchbook. As I leafed through this very personal journal, I felt over-whelmed that I had any part in the beauty that revealed itself. Simply by sharing a passion of mine, I had helped someone soul search and start again. I remain humbled by the experience.

Your sketchbook can be full of sketches. But it can be full of more. It can help you work through issues, solve problems, find your spirit. It can be full of what makes you, you.

Storytelling and Your Life

Learning to sketch and developing the habit of bringing your sketchbook with you can be very rewarding. Think about it. You are embarking on a life story that you may share with others or keep to yourself. All this by simply taking pencil to paper. Keep your sketchbook in a prominent place where you will see it every day. Open it and speak to it.

Your sketchbook will be one of a kind and very unique because you are recording what <u>you</u> choose to see in <u>your</u> world on any given day in <u>your</u> life. I find that very satisfying and exciting.

One reason why I teach is because I get to see the world in someone else's eyes. In some small way I can experience the world differently just by observing and talking about what they chose to sketch.

Throughout your adventure in sketching choose to tell an epic tale that goes on year after year. Whether you are sketching the city, your vacation, your family, objects you love and people you meet, do it with passion. Telling your story through sketching is an unforgettable experience.

Things to Observe and Record

People
Faces
Cats
Dogs
Bicycles
Motorcycles
Cars
Your body
Furniture
Kitchen Tools
Dinnerware
Buildings
Books
Drapery
Things that hang
Things that float
Things that fly, swim, walk or run
Food
Farmer's Markets
Clothing
Hands
Feet
Pencils or Pens
Plants
Smells
Noises
Love
Sleep
Poverty
Letters
Numerals
Imaginary Animals, Plants, Cars or Buildings
Insects
Bathrooms
Kitchens
Musical Instruments
Artworks
Craftworks
Holidays
Personal devices; Glasses, Hearing Aids, Wheelchairs,
Walking Sticks

Try:
Listening to music
Dancing or singing while you sketch
Writing a poem
Writing lyrics
Taking a hike
Taking a trip by boat, plane or train
Inventing something useful
Inventing something jolly
Looking up
Looking down
Listening to the city
Sharing your art
Writing a letter to someone

Assessing Your Progress

How is your sketchbook? Healthy and robust or anemic?
Are there sketches *and* words or is it somewhat mute?

Questions to ask yourself:

So far, what have I enjoyed most, least?
Have I been brave?
Have I been adventurous?
Am I "seeing" better?
Am I having a conversation?
What have I discovered about myself, our world, my world?
Does my visual journal, as a whole, tell an enduring story?
Am I sharing so I can inspire and be inspired?
Am I approaching this adventure with determination and resolve?
Have I brainstormed or researched for solutions?
Have I tried new mediums other than pencil?

10 Ways to Improve Your Sketchbook

1. **Annotate:** Write notes about what you draw and your experiences. Don't forget dates, colors, sounds, scents, dimensions, etc. to help you remember and make your book more interesting. Aide-memoire is valuable!
2. **Reflect:** Think about your choices. Why did you draw that subject? Why did it grab your attention? Why is it interesting to you? Was it a noise, scent or movement? Reflecting helps you move forward.
3. **Imitate:** Copy the masters. They are excellent teachers.
4. **Doodle:** Create imaginary objects or worlds. Sometimes, being non-sensical can jumpstart your creativity.
5. **Research:** Consider a specific topic. Make an entire sketchbook of trees, seashells, etc. Make it a mission to search and record.
6. **Explore:** Try different mediums suitable for sketching. Pencils, Pens, Watercolors or Colored Pencils are all fun. Be brave!
7. **Brainstorm:** Look for inspiration for ideas by interacting with others, on TV, listening to the radio, walking in a park, etc. Use the universe as your corroborator.
8. **Join:** Take art/craft classes to be with likeminded people, listen to a lecture and ask questions, tell someone a story, sing or dance with a group.
9. **Decorate:** Spice up your sketchbook cover by decorating it front and back. Make some sketches inside of the elements you used and where your ideas came from.
10. **Share:** Glean information, styles or mediums used, by sharing your sketchbook. Be someone else's inspiration and allow them to be yours!

Architectural Tips*

- Basic Lines and Shapes
 - ◊ Remember to look first at basic lines and shapes. Use sight sizing, framing and scale techniques to help your sketching.

- Shadows
 - ◊ Watch the shadow areas to help make what you are drawing appear three dimensional.

- Frescoes
 - ◊ The art of painting on fresh plaster with water-based paints. Notice the fresco on the ceiling. Remember to get that different perspective; look up and down.

- Mosaics
 - ◊ Notice the mosaics you find in public buildings. They are awe inspiring.

- Sculptures
 - ◊ Bas Relief: a sculpture jutting out from a flat surface like a wall. Look at the shadows.

- Lettering on friezes and buildings.

- Add some gestural drawings of people to show scale.

★NOTE★

In sketching there is no need to create perfectly straight or ruler straight lines even when depicting architecture. Remember, it is the story you are trying to tell. Have fun getting many aspects of architecture into your sketchbook.

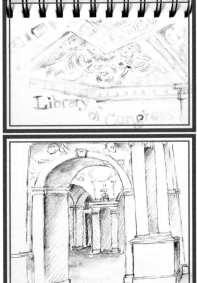

National Gallery of Art

"An Afternoon at NGA"

Your task for today is to do at least one quick sketch of each: Animal, Vegetable, Mineral

You may find a flower or a lion in a painting or sketch a marble (mineral) statue. You might get lucky and find all three in one piece of artwork; a deer, a tree, some gold coins. By having a task, you can keep yourself from being completely overtaken by the riches in our National Gallery and not getting anything down in your sketchbook. Save some time to sketch children playing around the Mercury fountain or a couple deep in thought over "Ginevra" (Gallery 6).

<u>Added Challenge</u>: Can you find any sketchbooks or sketches from famous artists on display in the NGA? Make a note in your sketchbook so you can visit them again. Artists often use the sketching or sketchbooking method to pre-plan a painting or sculpture.

Tips:

- Look at the contour line or the edge that defines the object from space so you can resist being paralyzed by details.

- Make notes or an aide-memoire to record any colors, noises, happenings, etc. to help you remember your day or why you chose to sketch a certain object.

- Be alert! Be courteous to folks around you by not blocking the view.

- It's okay to take a break, grab a snack or stare into space for a moment.

- I don't believe in forcing a creative endeavor. When you are done, you are done. After all, it *can* be over whelming!

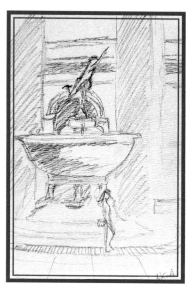
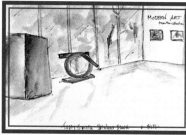
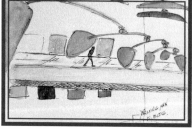
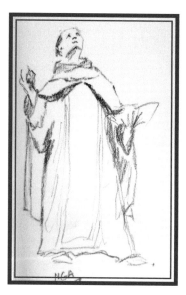

Natural History Museum

"Fin, Fur, Feather and Fossil"

Your task for today is to do at least one quick sketch of each: Fish, Animal, Bird and Dinosaur

Today is all about telling the story of texture. How do you tell someone how the scales of a fish look and feel or the fur of the tiger or skin of an elephant? Are the bird's feathers soft, spiky, rigid, long, short or perhaps too swirly to believe? How about the visual and tactile texture of a dinosaur bone, skin or egg?

Added Challenge: How many things can you fine and record just in this museum? Wool, skin, a duck's bill, bird legs, claws, teeth, many different eyes, ears?

Tips:

- Think not only about the animal sketch but also of showing the texture. Use cross hatching or dots to depict course skin or sweeping lines for feathers. However you feel you want to sketch what you see is fine. It is your sketchbook and your story to tell.

- Don't forget to sketch what is happening around you. Sketch a mom explaining what a dinosaur is to her child, for instance.

- Make notes or an aide-memoire to record any colors, noises, happenings, etc. to help you remember your day or why you chose to sketch a certain exhibit.

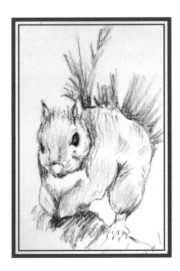 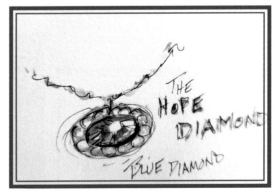

National Museum of the American Indian Washington, DC

"Fortitude"

Your task for today is to do many quick sketches of the treasures from our native peoples. Include color in at least one of your sketches. Create a sub-story or sub-sketch of one object such as a quick sketch of a necklace and then a more detailed sub-sketch of the delicate beadwork.

Today is all about telling the story of the spark, spirit and style of these unique and artistic people. Grab inspiration by inhaling their stories and appreciating the workmanship in creating beautiful, useful objects.

Added Challenge: Add a poem, song lyric or one creative work to enhance your sketches.

Tips:

- Because this museum is dark to preserve the colors and fragile nature of the objects, don't be afraid to get close to see what you are sketching. Just remember not to touch even the glass cases.

- Simple shapes can depict so much. Ovals, circles. triangles, squares are everywhere in our universe.

- Use your experience with textures to tell us about the horsehair, wood, skins or twine used.

- Don't forget about this remarkable building that was built with a sanctuary feel. Can you believe those spiraling steps?

 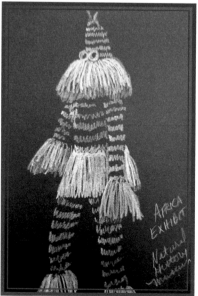 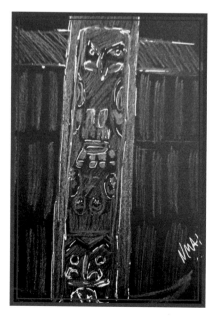

Library of Congress

"Inquiring Minds"

Your task for today is to do many quick sketches of architectural elements by paying attention to and utilizing shadow and light. How does the shadow define the arch or curve of a statue? Use all 3 levels to affect your perspective of this beautiful building. Look up and down by traveling from floor to floor sketching as you go.

Today is all about telling the story of architecture. The building itself, the textures of elements that make up the building. structural elements like columns, decorative elements like frescoes and statues. Eye appeal that differentiates one building from another like domes, mosaics, arches, etc.

Added Challenge: How are the windows adding to the visual appeal by bringing the outside inside?

Tips:

 See Architectural Tips

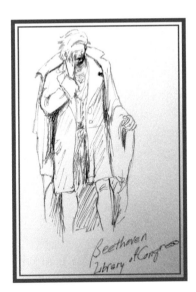

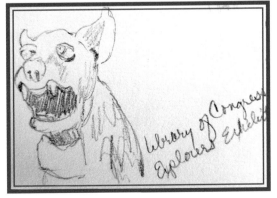

United States Botanical Gardens

"Botanical Expedition"

Your task for today is to do many quick sketches of your botanical discoveries and record the shape, textures, colors and details.

Today is all about telling the story of the plants and happenings here in this beautiful garden. Pretend you are on an exhibition to the desert, tropics or a secret garden and you must tell the folks back home about the wondrous plant life.

Use all your experience to help tell the story by using what you have learned; contour line, negative space, color, texture, sub-stories, aide memoire and architectural techniques to name a few.

Remember, perfection is not the key here. Try not to spend too much time recording detail of what you see but getting the essence of what you see, hear and feel.

Added Challenge: Can you record the biggest and smallest leaf? Smoothest plant versus the prickliest cactus? Fuzzy, smooth or spiny flowers? Roots and compost? Can you express the silence of the gardens and the bustle of the people? Record your thoughts about this place and how it makes you feel.

Tips:

- Walkways are narrow but you can find a little nook here and there to quick sketch.

- Use all levels to gain perspective. Careful on those stairs. They can get wet. Try drawing the same plant from below and above.

- Use your experience with textures to tell us everything.

- Don't forget to sketch people inside and outside. It's all part of the story.

- Sketch the glass building from outside. Take a walk in the outdoor gardens. Come back during the changing of the seasons for a different view.

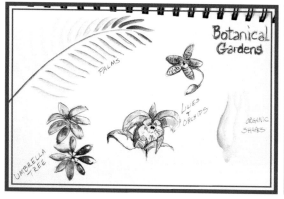 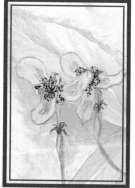 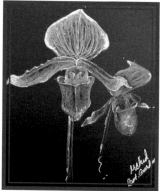

All Around the Town

Washington, DC has so much to offer the sketching artist. Whether you love architecture, green spaces, events and happenings it is all here for you to capture in your sketchbook.

Part of the thrill of sketchbooking is finding things to record. In a city such as Washington, DC there are so many we could not possibly list them all. Now you must be adventurous. Take a friend along and start walking or riding around the area to see not just the highlights of famous buildings, museums and memorials but also the unique architectural styles and parks we have here in our nation's capital. A fun fountain, lamp post or clock may be a worthy sketch. How about a sketchbook of all the sculptural gargoyles and grotesques on our beautiful buildings? Get a quick sketch of the many tourists and school groups that flock to our city. Why not sit at a café or at Union Station and people watch? Public transportation makes it easy to go from one end of the city to the other. Take in all the festivals and make sketches of the movement of people or our wonderful cherry blossom trees while paddle boating. It is all here for you. You just need to be brave, be observant and do some Capital Sketching!

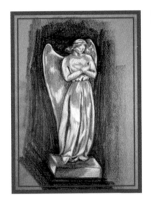 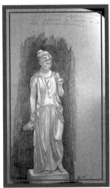 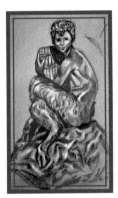 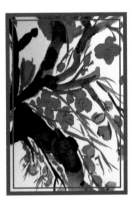

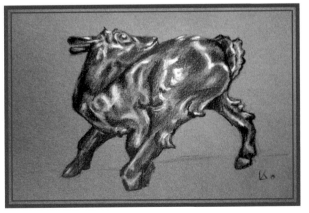 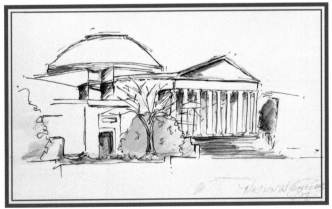

Inspiration!

Enjoy these inspirational sketches by fellow sketch bookers, Kent Morgan and Sarah Donnelly.

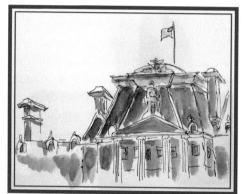

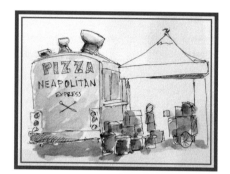
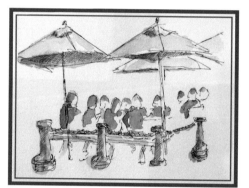

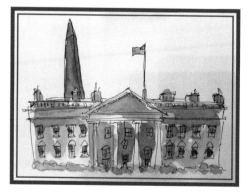

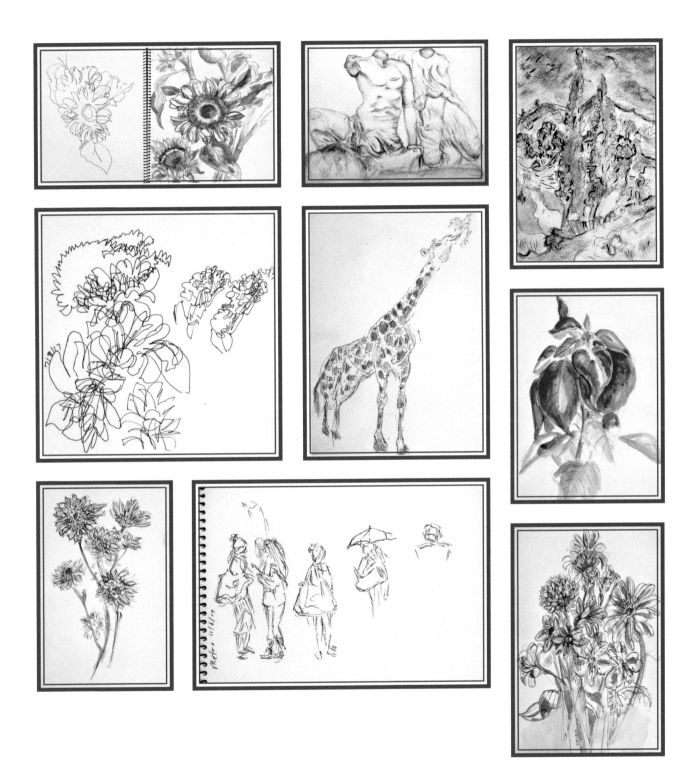

Printed in the United States
By Bookmasters